$195

JN

MANGROVE WILDERNESS

NATURE'S NURSERY

TEXT & PHOTOGRAPHS BY
BIANCA LAVIES

DUTTON CHILDREN'S BOOKS
NEW YORK

This book is dedicated to you, Cathy

For sharing time and knowledge
the author wishes to thank:
Dr. Eric J. Heald, president of Heald and Associates, Inc.
Dr. Bernie Yokel, president of the Florida Audubon Society
Dr. Herbert Kale, vice president of ornithology,
 the Florida Audubon Society

Library of Congress Cataloging-in-Publication Data
Lavies, Bianca.
Mangrove wilderness: nature's nursery / Bianca
Lavies. — 1st ed. p. cm.
ISBN 0-525-45186-2
1. Mangrove swamp ecology—Juvenile literature.
2. Red mangrove—Ecology—Juvenile literature.
[1. Mangrove swamps. 2. Swamp ecology.
3. Ecology.] I. Title.
QH541.5.M27L38 1994
583'.42—dc20 93-33956 CIP AC

Published in the United States 1994 by
Dutton Children's Books,
a division of Penguin Books USA Inc.
375 Hudson Street, New York, New York 10014

Designed by Sylvia Frezzolini and Rosemary Buonocore

Printed in Hong Kong First edition

10 9 8 7 6 5 4 3 2 1

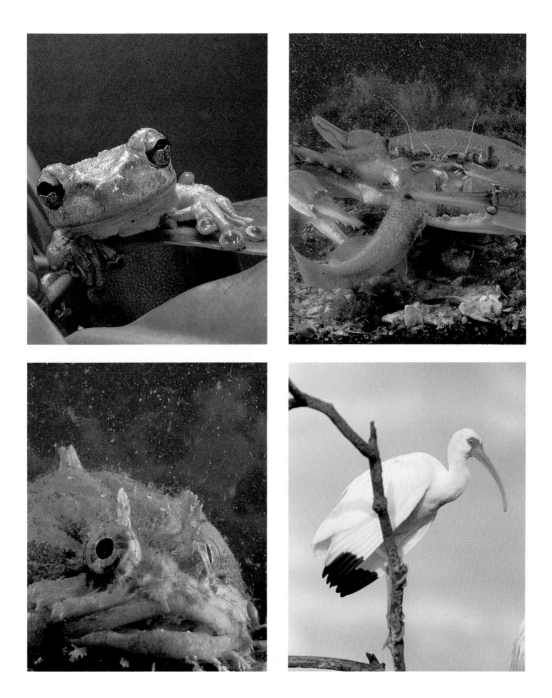

A frog, a crab, a fish, and a bird—these four creatures, and many more, hunt, seek shelter, and raise their young in forests along the southern coast of Florida. They are part of a vast web of animal life that is supported by a remarkable kind of tree: the red mangrove.

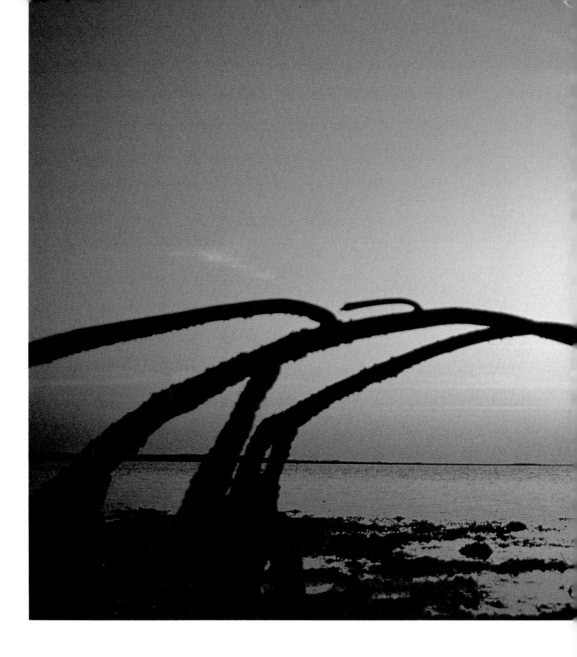

It is an odd-looking tree that seems to stand on stilts, and it grows where few other trees can—in salt water. The stilts are actually the mangrove's roots. They are called prop roots, because they help prop, or support, the tree against the ocean's strong waves and tides.

Red mangroves grow in warm tropical regions near the earth's equator. In Florida they flourish along the edges of the swampy Everglades, at the southern tip of the state. There the land is broken up into thousands of small islands by inlets and waterways. The trees thrive in these inlets, or estuaries, where fresh river water leaves the land and meets the salty ocean tides. The water around

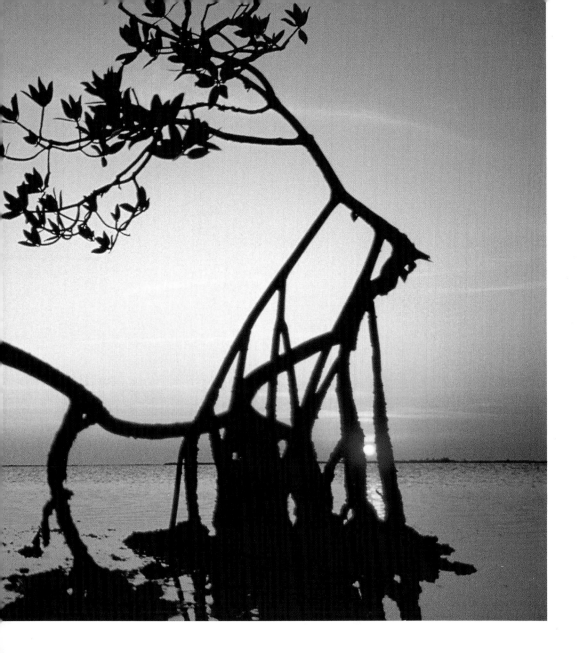

the trees takes on a reddish color from the natural dye, tannin, in their bark.

A red mangrove tree produces about three hundred seeds a year. By no means do all the seeds survive, but if the conditions are suitable, a lone red mangrove like this one will be surrounded by a forest of young trees in about twenty-five years.

The new forest will be a nursery for all kinds of wildlife. Creatures from the tiniest worms to huge birds, like pelicans, will be able to find food, shelter, and safe nesting places among the mangroves' tangled roots and full branches.

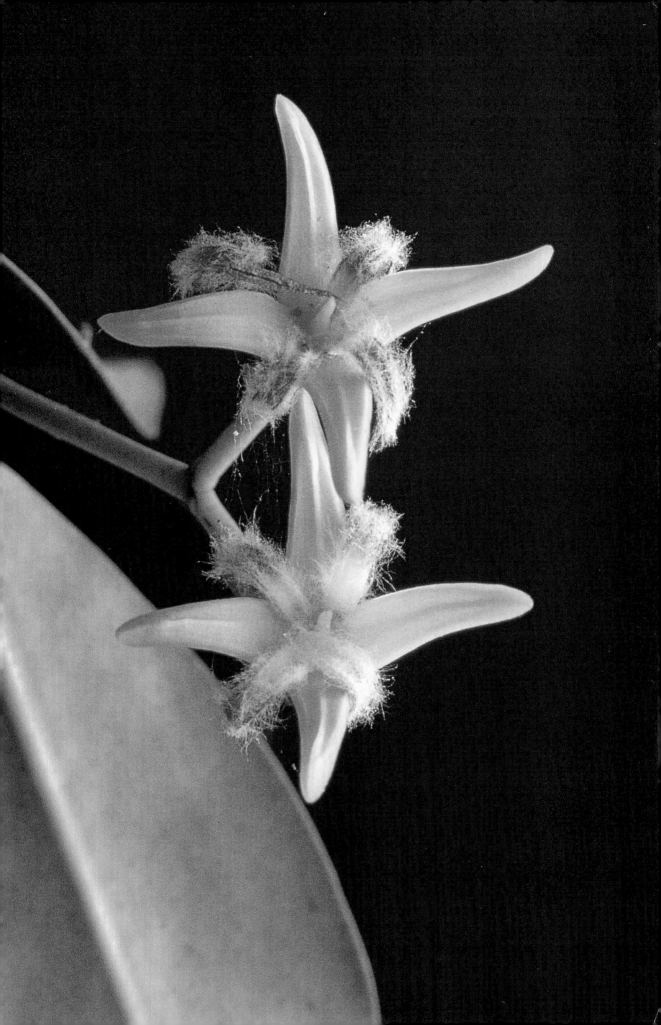

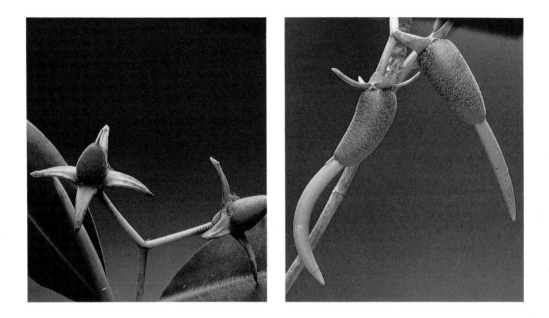

Bright yellow flowers are the first step in the formation of mangrove seeds. More than a thousand flowers bloom on each mature tree in the spring. After a month, the inch-wide blossoms drop off, leaving behind rust brown fruits the size of plums. Each fruit contains a single seed.

In about two months, something unusual happens. The seed inside each fruit sprouts into a seedling. The root end emerges from the fruit first, followed by the stem.

The seeds of most kinds of trees do not begin to sprout until they have fallen off the parent tree and landed on warm, moist earth. But if the red mangrove seeds were simply to drop, the salt in the ocean water would keep them from sprouting. So the seeds take advantage of their parent tree's ability to extract nutrients and moisture from the water and soil without taking in any harmful salt. Staying attached, the seeds grow into six- to twelve-inch seedlings that are themselves salt-resistant.

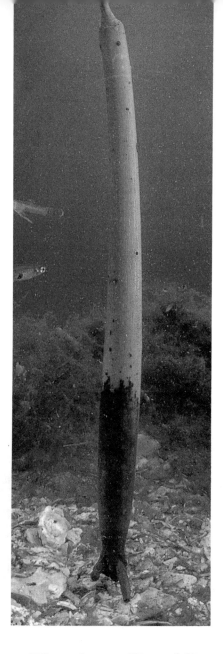

These cigar-shaped seedlings, called propagules, have a store of nutrients to keep them alive after they drop into the water. They are also buoyant and can float away, out of the shade of the parent tree, to areas where they will have more room and sunlight to grow.

When the seedlings fall, some drop like darts, root end first, into the sandy shore or the shallows. These seedlings put down roots near the parent tree. Others float in a horizontal position until their root ends become waterlogged and heavy. The weight pulls the root ends down, and the seedlings float with their stems upright. They may drift for thousands of miles, living up to a year, before they come to shallow water. Then, like the seedling in this photograph, their root ends bump along the water's bottom. This triggers the growth of a network of small roots that eventually catch in the soil. Scientists believe the red mangroves in Florida are the descendants of seedlings that drifted all the way from Africa.

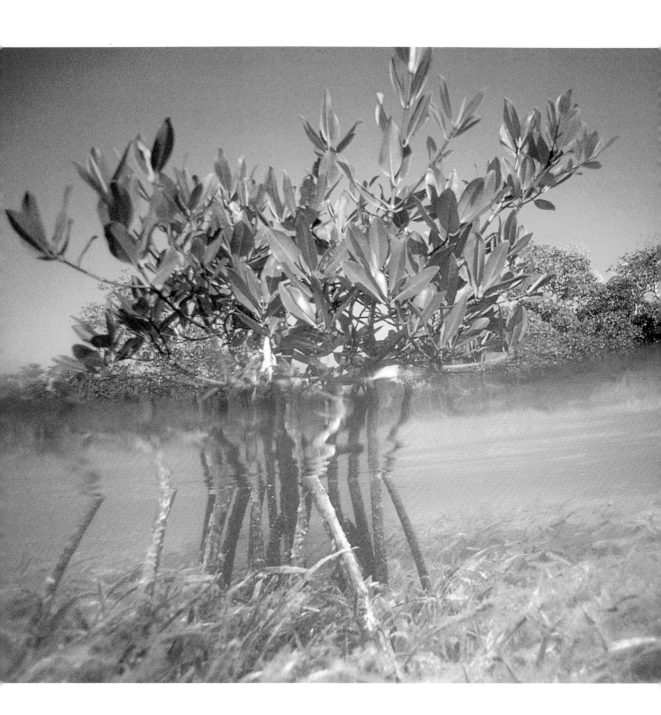

A couple of years ago the tree in this photo was a six- to twelve-inch seedling. Now it is about two feet tall. It will continue to grow several inches a year throughout its life. The average height for a red mangrove in Florida is thirty feet, but if the conditions are good, this tree could grow to be eighty feet tall.

The red mangrove's distinctive prop roots, like those in the photo, appear in its third or fourth year. These long arching roots are useful to the tree in many ways. Besides giving support, they are able to absorb water from the estuary or ocean without taking in salt, which would rob the tree of moisture and eventually kill it. And the portion of the roots exposed to air can absorb the oxygen that the tree uses to gain energy from food.

Like all trees, the red mangrove makes its own food in its leaves by a process called photosynthesis. This process converts sunlight and carbon dioxide into a kind of sugar. Oxygen helps the tree turn the sugar into the energy it needs to grow taller and to produce new roots, leaves, fruits, and seedlings.

The red mangrove's roots extend a foot or more into the soil at the water's bottom. They help stabilize and build up the soil. Floating leaves, twigs, and grasses get caught in the maze of mangrove roots, and as this debris piles up, it gradually decays and becomes part of the soil that nourishes and helps support the tree.

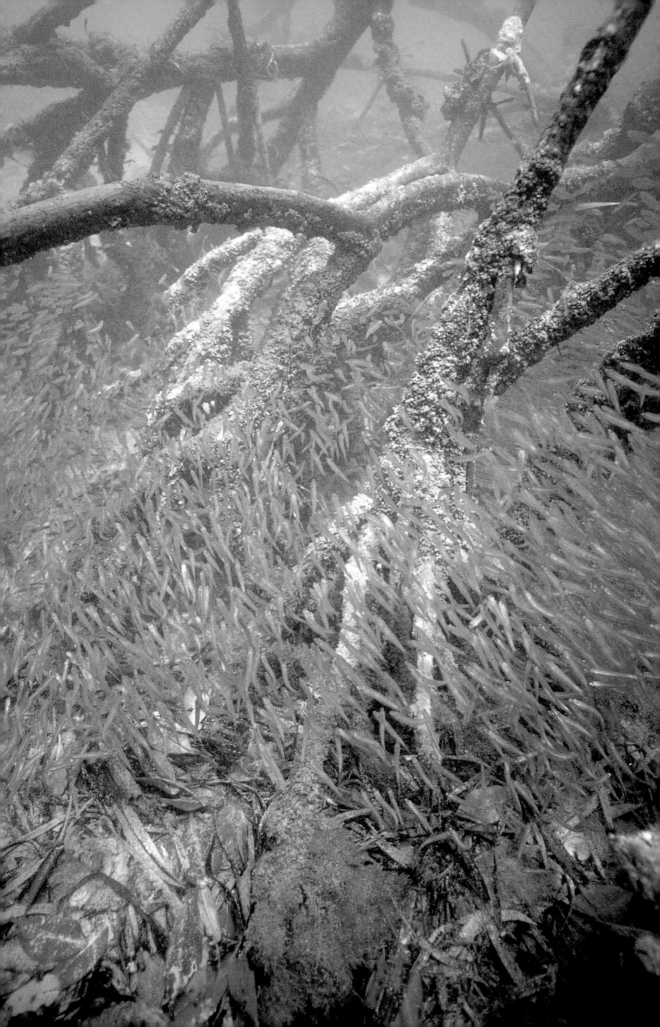

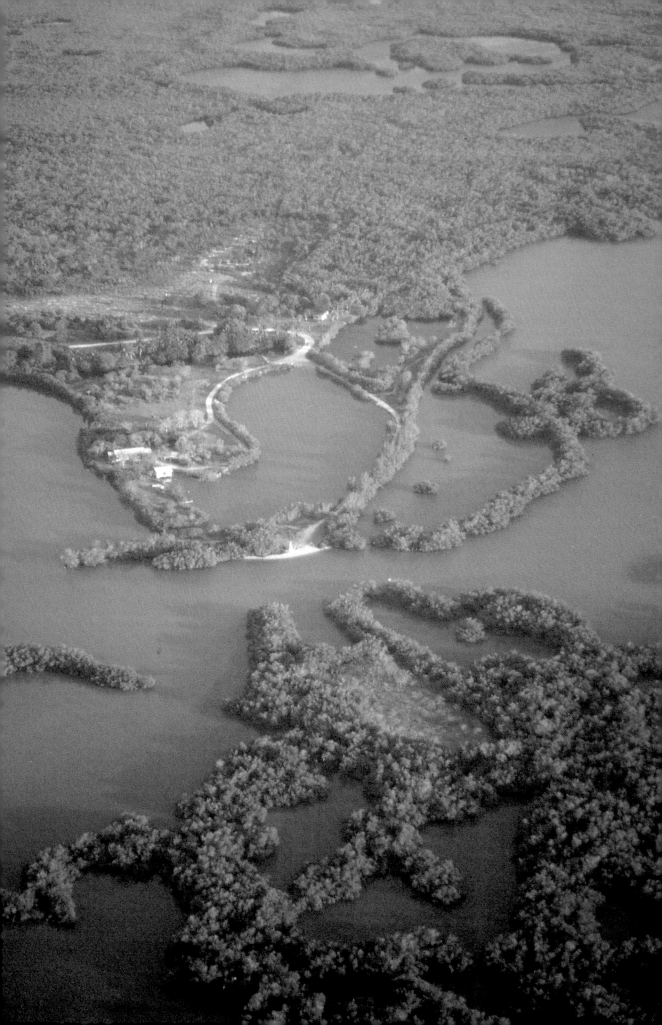

Red mangrove trees grow best in shallow water like that around the oyster bars off Florida's southwest coast, pictured here. Oyster bars are underwater mounds made up of colonies of living oysters and the shells of their dead predecessors. The water around these bars, which is often only one or two feet deep, is ideal for red mangroves. The trees actually turn oyster bars and sandbars into islands. As debris in the roots becomes soil, land eventually forms around the trees. Red mangroves that once sprouted around old exposed coral reefs helped to create the islands we call the Florida Keys.

Once the ground is built up around the red mangroves, other kinds of mangroves—black, white, and buttonwood—move in. But red mangroves are usually first, and most often at the water's edge. They seem to be the most successful at growing in tidal salt water, and their strong roots are best able to withstand storm winds and waves, preventing the land around them from being washed into the sea.

However, storms with extremely high winds, like hurricanes, can uproot even the sturdiest red mangrove trees. Hurricane Andrew swept through southern Florida in 1992, destroying mangrove forests along twenty miles of coastline. But because the seedlings can live for a year in the water, new young trees soon sprouted where the old ones once grew.

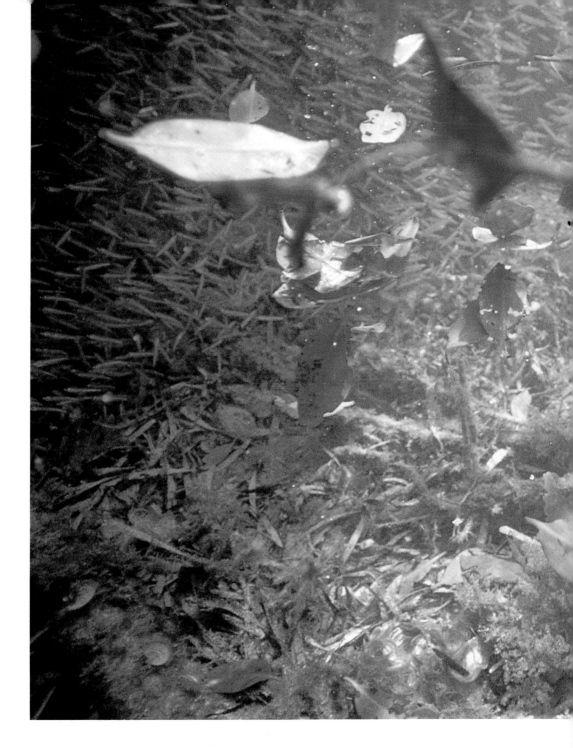

The mangrove leaves floating in this picture are an essential part of the mangrove wilderness food chain. Even before the leaves fall from the trees, they are food for airborne bacteria and fungi. These microscopic life forms are able to break down a material in the leaf called cellulose that many other creatures cannot easily digest. Once the leaves drop into the water, more bacteria and fungi attach to them, making the leaves rich in

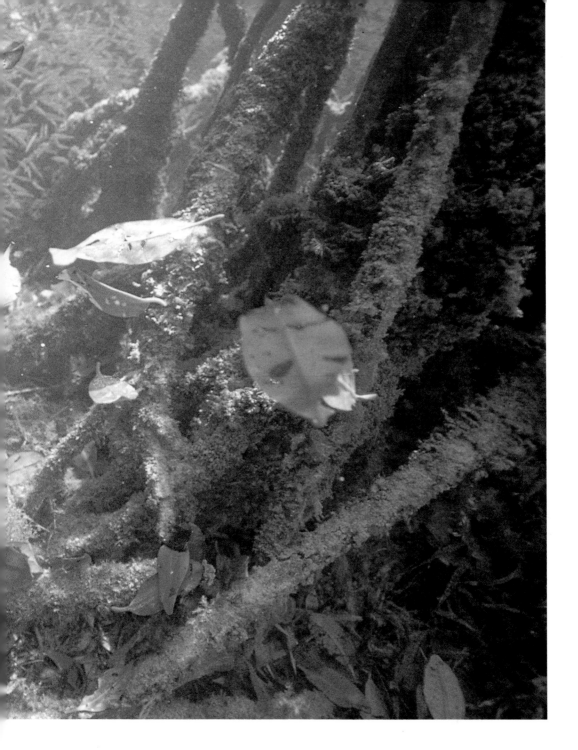

protein, and good food for larger animals. Small crabs and other crustaceans gnaw at the leaves, breaking them into pepper-speck bits called detritus.

Pink shrimps and many kinds of worms, mollusks, and crabs dine on the detritus. They are eaten by small fish, which are in turn eaten by larger fish. The larger fish are themselves eaten by birds, continuing the food chain.

In this photograph, hundreds of mangrove snapper and other fish hunt for smaller fish among the gray green shadows of the mangrove roots. Orange sponges, oysters, and other filter feeders cling to the roots, trapping tiny particles of detritus as

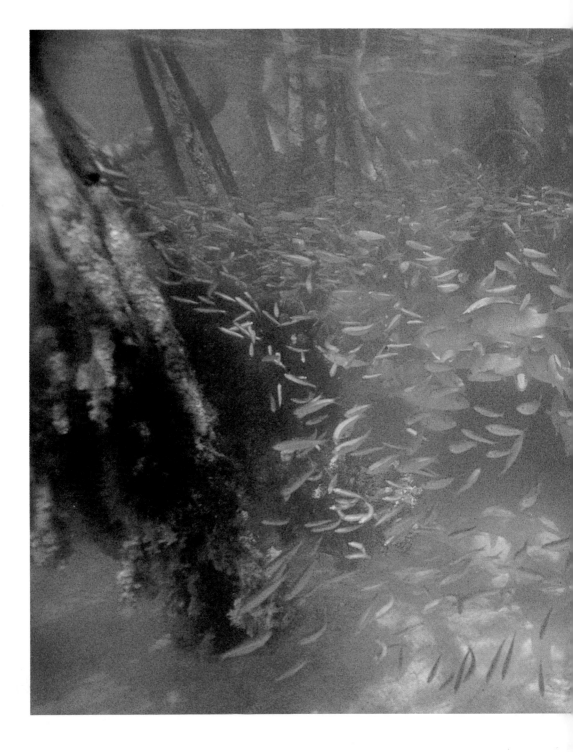

they strain water through their bodies. We humans eat oysters, fish, shrimps, and other animals from different stages of the food chain supported by the red mangrove trees.

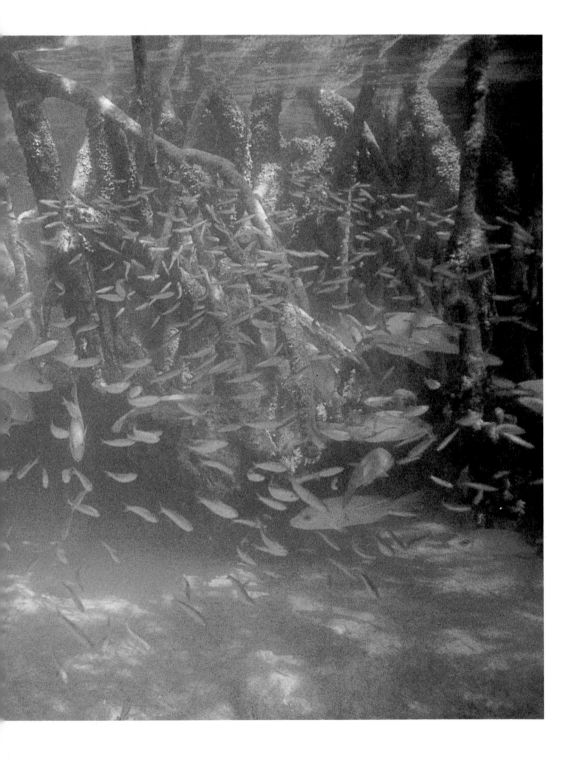

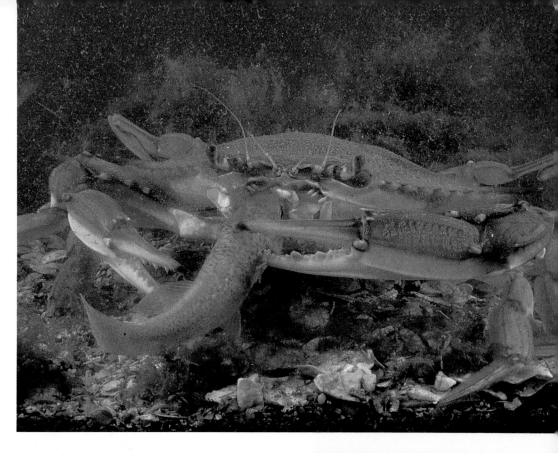

This blue crab is shoving a killi-fish into its mouth. Normally the killifish that live among the mangrove roots are too quick for the crab to catch. But this one was injured and therefore unable to escape. Usually the crab eats less agile creatures, such as small clams, mussels, and shrimps.

Decorator crabs eat mangrove-leaf detritus, marine worms, and small shrimps. The one in the picture at right is camouflaging itself with branches of a plantlike animal called a hydrozoan that it has snipped off with its sharp claws. With the branches snagged on its spines, the crab is hidden from the large fish and birds that hunt it.

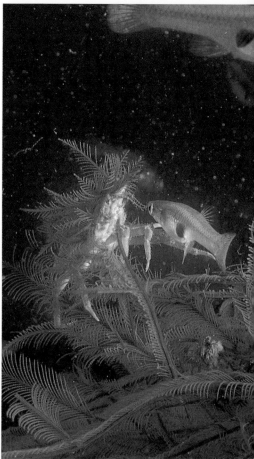

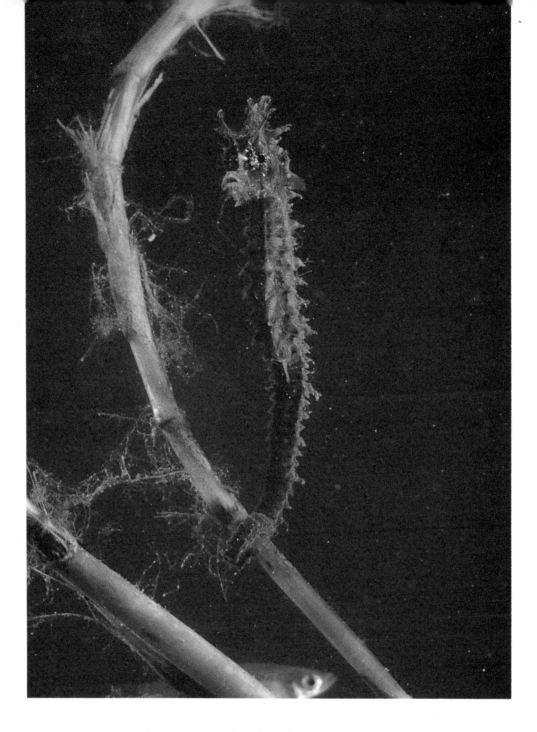

Nearby, a sea horse uses the tip of its tail to cling to a mangrove stem. With its long tube-shaped mouth, it sucks up tiny organisms, such as shrimp larvae and plankton. Like a chameleon, it can hide from predatory fish by turning the color of its surroundings.

There is something else very unusual about sea horses. They are hatched from eggs carried by their father, rather than by their mother. She deposits the eggs in the father's brood pouch, and he guards them until they hatch.

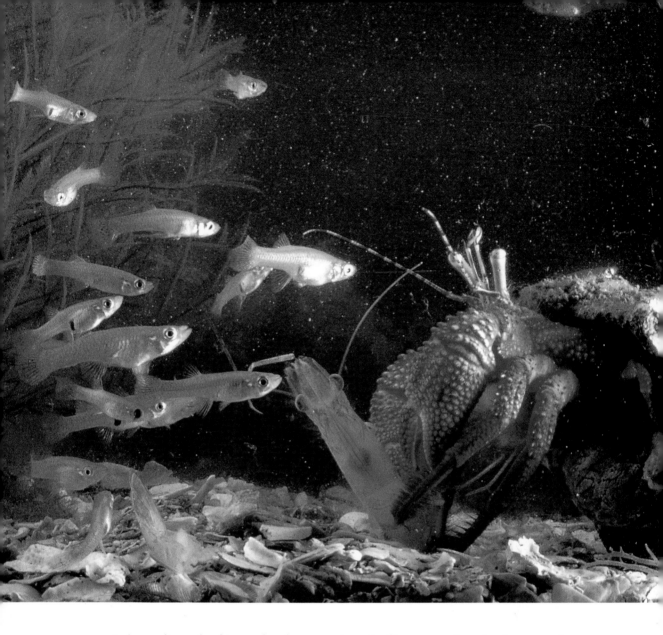

A hermit crab sits on broken oyster shells as a school of mosquito fish hovers nearby. They are waiting to snatch some floating bits of the pink shrimp that the crab is eating.

A hermit crab has a soft abdomen that it protects by living in a shell that once belonged to another animal. The hermit crab here has borrowed a conch shell. When it outgrows its shell, it will look for a larger one.

The young pink shrimp in the photograph at right is eating a tiny mosquito fish. Pink shrimps hatch in the Dry Tortugas Islands, about one hundred miles off the southwest coast of Florida. As tiny shrimp larvae, they drift and swim on the tides to the mangrove forests to feed and grow. When they are mature, they will return to

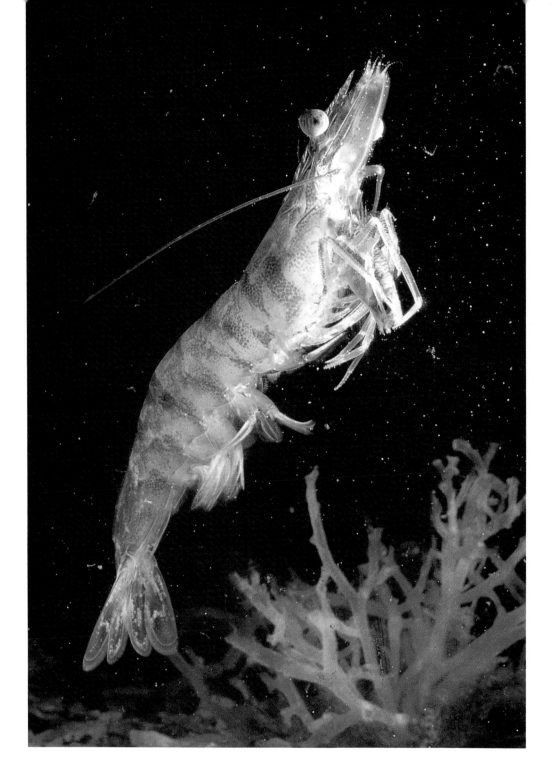

the Tortugas. There the females will produce up to five hundred
thousand eggs each. If the eggs are fertilized by male shrimps, they
will grow into more shrimp larvae that will find nourishment in the
mangrove nurseries.

But most shrimps do not make it back to the Dry Tortugas Islands.
Many become meals for animals like crabs, herons, or perhaps…

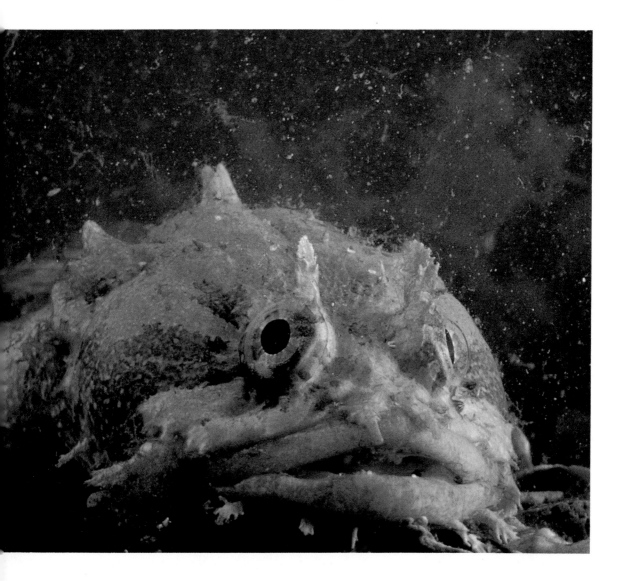

...this toadfish, waiting to catch its dinner.

Look out for the toadfish! It has four poisonous spines on its back that cause painful stings. And the male toadfish guards the family's eggs by viciously biting all intruders. The female is not very particular about where she lays her eggs—an old shell or even a tin can or soda bottle will do.

Occasionally an alligator enters the coastal mangrove forests from its inland home in the grassy swamps of the Everglades. A young alligator like this one will eat the many pink shrimps, small fish, and crabs in this rich marine feeding ground. But a fully grown alligator would visit the mangrove forest in search of big fish and such mammals as a raccoon.

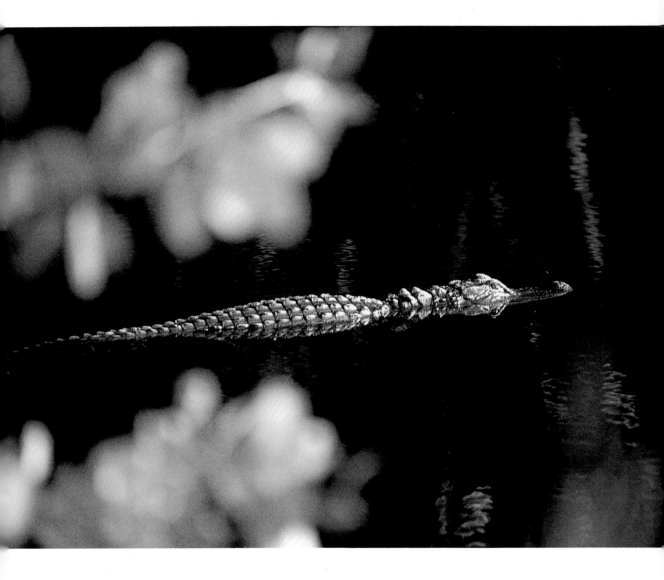

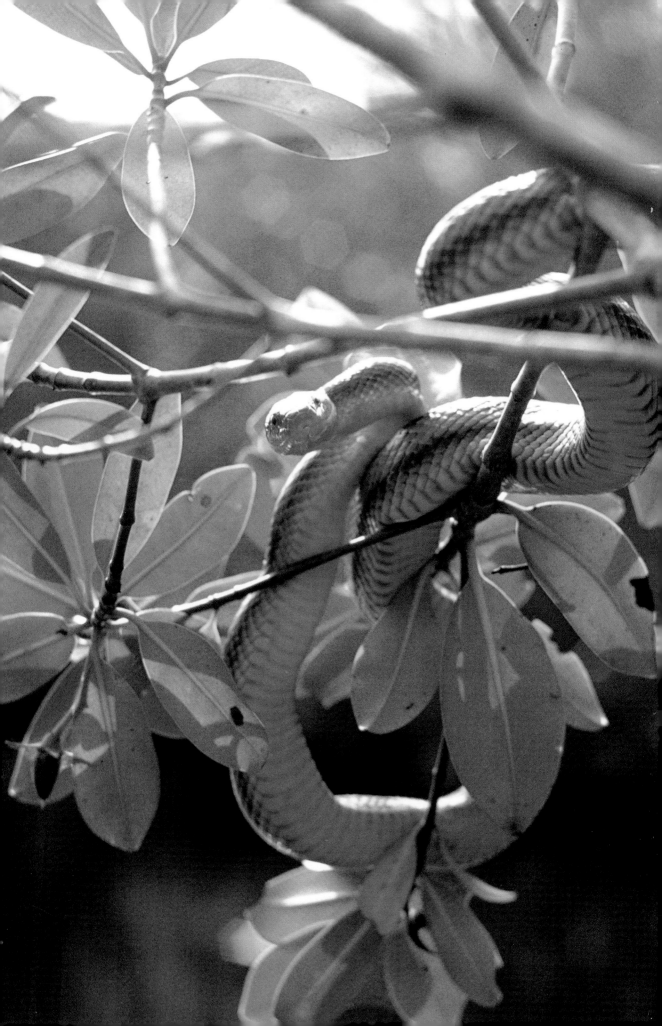

In the branches of a red mangrove tree, an Everglades rat snake is waiting silently to snatch a small rodent, bird, or tree frog. A rat snake is a constrictor. When it catches a meal, it does not eat the animal immediately but curls its body around the creature and squeezes until its prey is no longer moving.

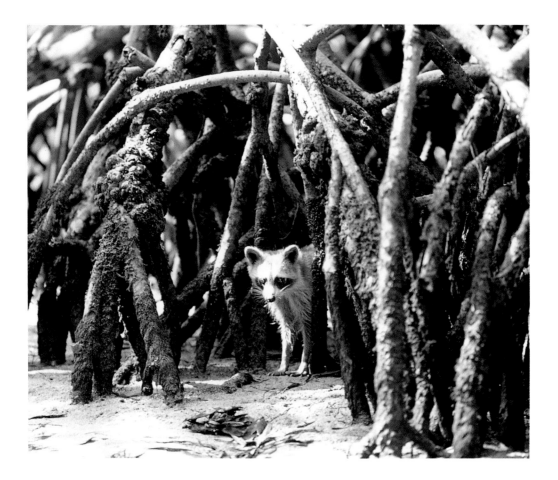

At low tide, a raccoon pokes its long nimble fingers among the mangrove roots, searching for crabs. Strong, sharp teeth allow the raccoon to eat hard-shell crabs and other shellfish. But this stealthy predator's favorite food is coon oysters, which it can find clinging in huge clusters to the sturdy mangrove roots.

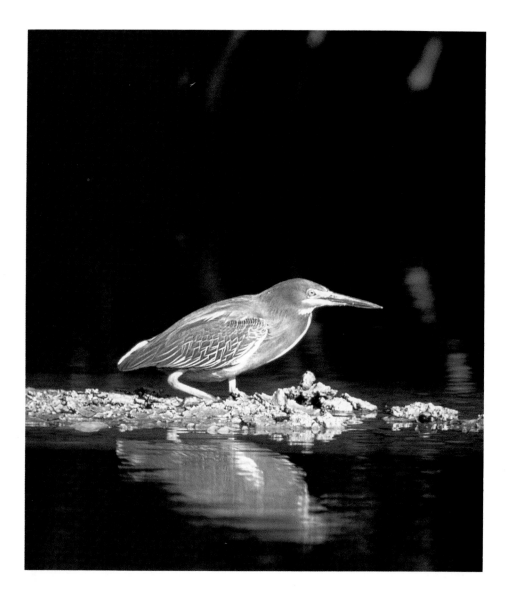

Early in the morning, a green-backed heron stands motionless
at the water's edge. The bird has left its roost among the mangrove
branches to search for fish, worms, or insects to eat. Nearby,
a snowy egret stands equally still, watching for fish or shrimps.
Both birds will strike swiftly, grabbing their prey with daggerlike
beaks.

Green-backed herons and snowy egrets are just two of more
than twenty different kinds of birds that inhabit the red mangrove
forests.

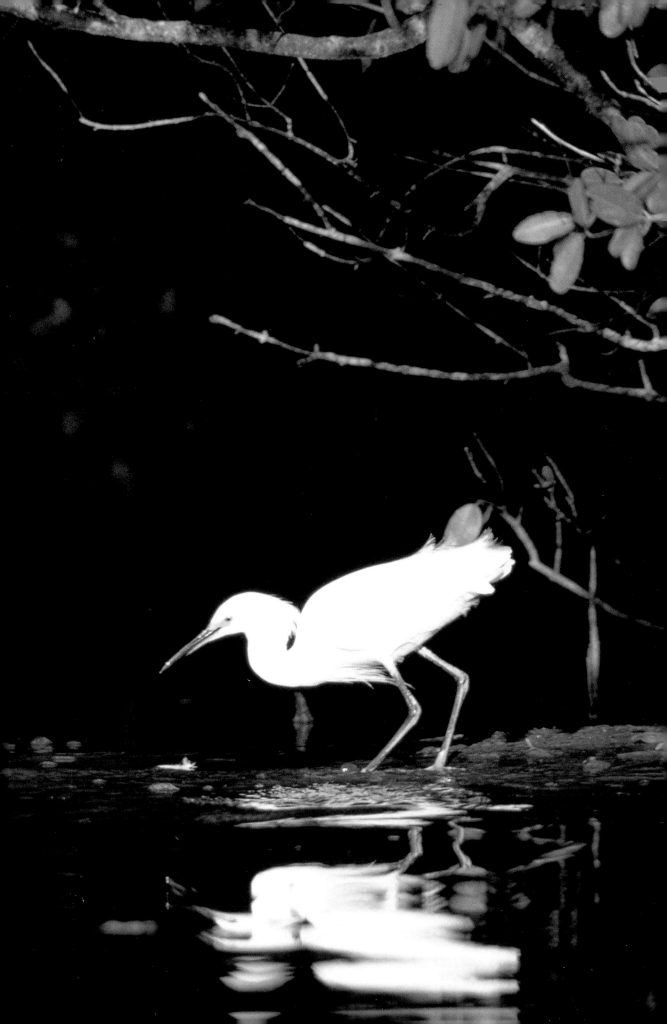

On an island formed by mangroves, two brown pelicans are building their nest. The male collects leaves and sticks from neighboring mangrove trees, preserving the branches of his own. He returns to the nest high in the leafy canopy, and with a clumsy flapping of his wings, he swoops to present the building material to his mate.

The islands are safe nesting places, or rookeries, for birds. The surrounding water offers a measure of protection from the egg-eating raccoons and snakes. And with so many birds nesting and roosting together, one is sure to spot an enemy, such as a swimming raccoon, in time to squawk a warning to the rest.

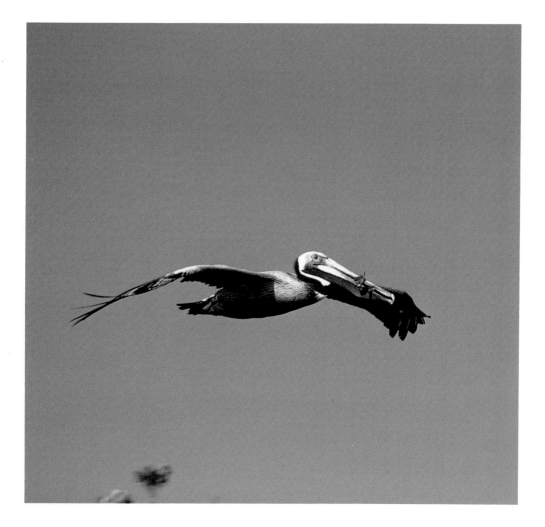

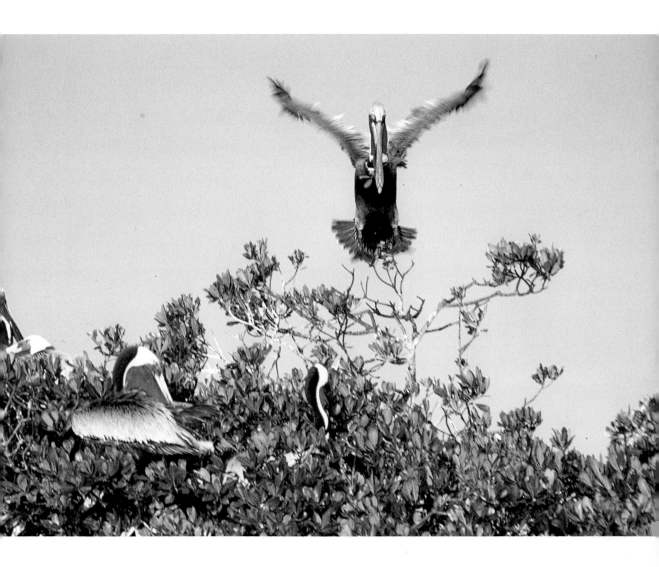

When the pelicans' bulky nest is ready, the female will lay three white eggs, as she does each year. The male takes his turn sitting on the eggs, sharing the monthlong incubation duties with the female. Once the pelican chicks hatch, they will remain in the nest for nearly three months. They eat by taking bits of regurgitated fish from the bills of their parents.

Perhaps you have seen pelicans flying very low over the water. When they see a fish, they crash-dive, scooping it up in their pouch. Though the pouches are large and roomy, the pelicans do not use them for storage; they swallow their meal immediately.

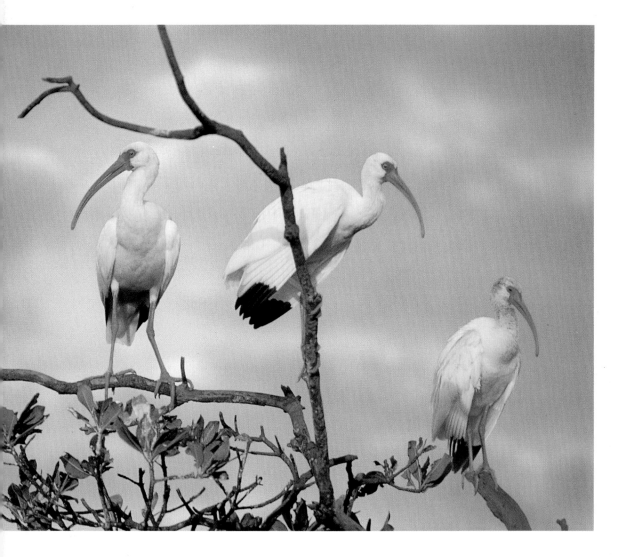

These three white ibis have just landed on the mangrove island where they spend every night. As the day ends, thousands of birds, including herons, egrets, cormorants, frigate birds, and pelicans, arrive at their own special mangrove islands. There is a lot of squawking as the birds jockey for perching space. Some dive into the water for one last meal, then return to their branches as the light fades.

Suddenly the sun is gone. Silence follows. The birds settle down to sleep and gather strength for another busy day in the red mangrove wilderness.

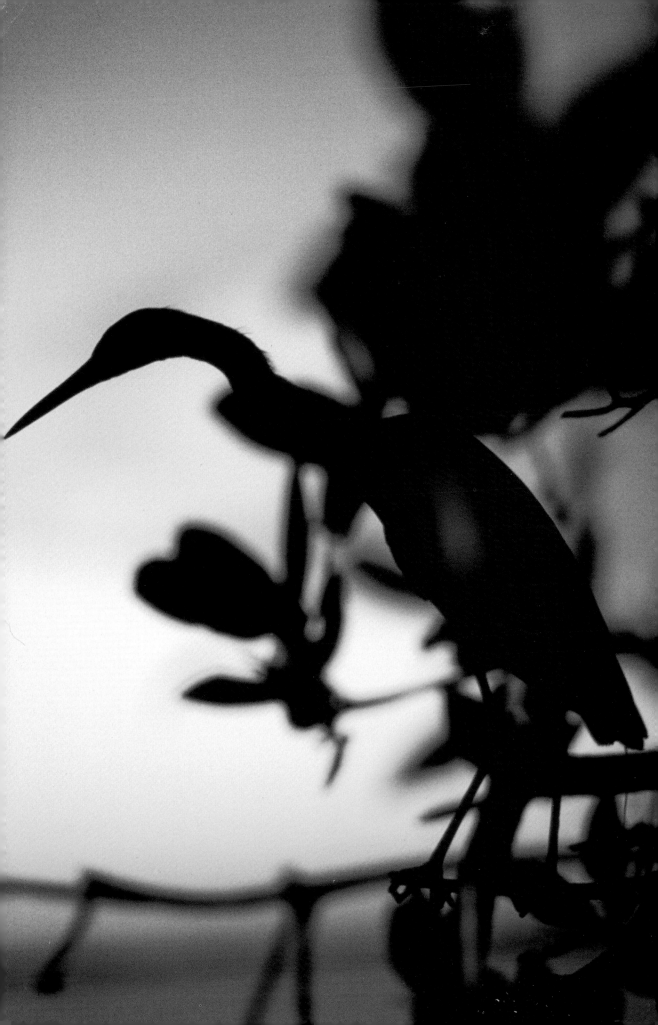

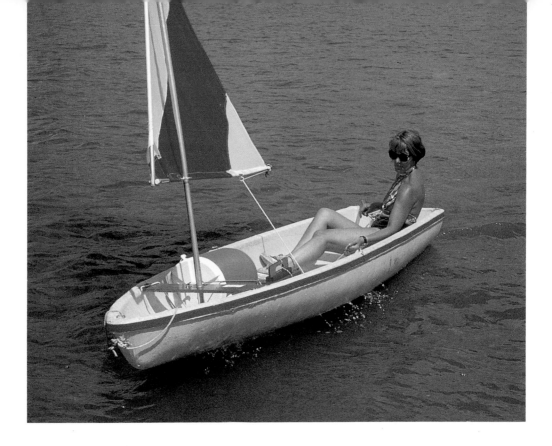

 To take the pictures in this book, Bianca Lavies navigated her small sailboat off the southwest coast of Florida from one mangrove island to another. She kept her camera equipment safe and dry in a cooler, just in case her boat capsized.

 "While I was standing in the water and needed to change film," she says, "the boat made a handy dry platform to put cameras and lenses on. Later I added oars, to use when the wind dropped, and a tent called a bird blind. The tent hid me and my cameras so that I wouldn't frighten the birds as I took my photographs through a hole in the side.

 "It was one big, exciting adventure to get these pictures. For two months I stayed in an old house in a mangrove swamp, together with three-inch spiders and a coral snake that occasionally appeared in my bathroom. I could not drink the water from the tap—it was brown and it stank. But I had all the space and all the animals to photograph I had always dreamed of.

 "For the underwater pictures, I swam among the roots from sunrise to sunset. Then I feasted on freshly caught lobster cooked on a fire near the water's edge, while raccoons tiptoed by looking for oysters on the mangrove roots.

 "Sand flies and fleas feasted on me—taking their turn in the mangrove food chain!"